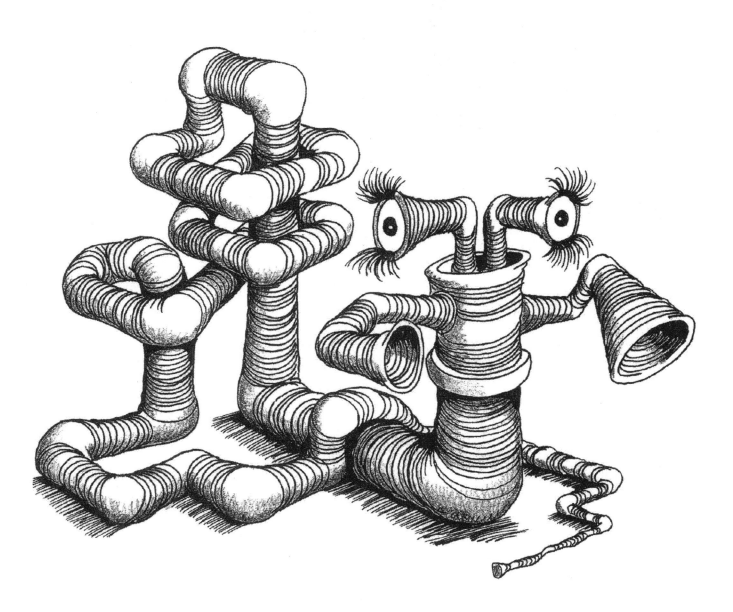

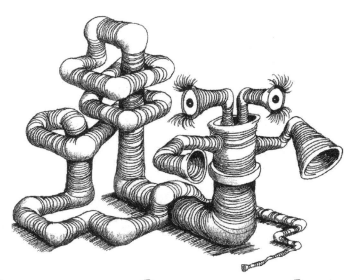

DRAW! DRAW! DRAW!
ROBOTS, GADGETS & SPACESHIPS

DRAW! DRAW! DRAW!
ROBOTS, GADGETS & SPACESHIPS
with Mark Kistler

Author Planet Press

Draw! Draw! Draw! series by Mark Kistler includes:
Monsters & Creatures
Cartoon Animals
Crazy Cartoons
Robots, Gadgets & Spaceships

Source: This work is an expanded edition of the book initially titled *Learn to Draw in 3D: Gadgets & Gizmos*, published by Scholastic Inc. in 2002

Publication facilitated by Author Planet Press, 2014

Author Planet Press
7741 South Ash Court
Centennial, CO 80122
www.authorplanet.org

Additional material by Mark Kistler
www.MarkKistler.com

Designed by Carissa Swenson
Additional Design for Expanded Edition by Chuck Crouse
Cover illustration by Mark Kistler
Illustration inking by Chrysoula Artemis of Starlight Runner Entertainment

ISBN: 978-1-939990-06-8

vi

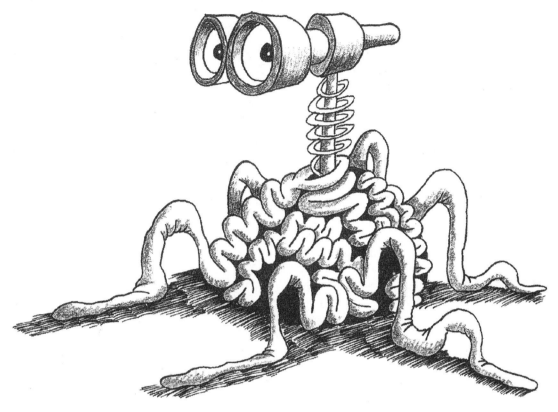

To my mother, Joyce Kistler. She was selected as a 1996 Reader's Digest American Hero in Education and she still finds time to read about 93 books at year!

WHAT'S INSIDE

Why Drawing in 3-D Matters

Greetings, future 3-D cartoonists!

Before we start our drawing in 3-D adventure, I want you to sit up straight in your chair, stretch, and look up at the lamp on the ceiling or across the room. Pay close attention to the metal, glass, and plastic casing around the lightbulb. Now look at the door. Notice the doorknob and the hinges. Then look at the table. Check out the edges, legs, and tabletop. Finally, look at the pencil you have in your hand. Can you tell me what all these things have in common?

Each one of these objects—along with almost *everything* that moves, stands, rolls, flies, covers, or tunnels—had to be designed and drawn in three-dimensions by an artist before it could be manufactured.

So, as you practice drawing the fun gadgets and gizmos in this book, just imagine that you are the 3-D engineering genius of the next generation of builders and inventors!

MARK KISTLER

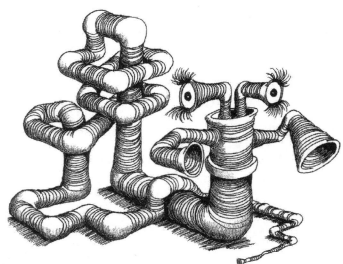

DRAW! DRAW! DRAW!
ROBOTS, GADGETS & SPACESHIPS

WHAT YOU NEED TO GET STARTED:

1. Pencil
2. Paper

That's it! A sharp pencil and a blank sheet of paper are the only items you need to launch your brilliant imagination into the galaxy of cool cartooning in 3-D adventures!

BONUS SUPPLIES

To help you practice your important drawing skills every day, here is a list of bonus supplies you might want to collect over the weeks and months ahead:

1. Mechanical pencil 9mm hb lead (medium tip — good for blocking in sketchy lines)
2. Mechanical pencil 9mm b lead (soft tip)
3. Mechanical pencil 9mm 2b lead (softer tip — good for shading)
4. Pack of 6 to 12 paper stumps (for blending your shading)
5. Several spiral bound blank sketchbooks in different sizes
6. A pack of colored pencils
7. A few fine and ultrafine black ink pens/markers
8. A special book bag to hold your supplies — your own "cartooning kit"

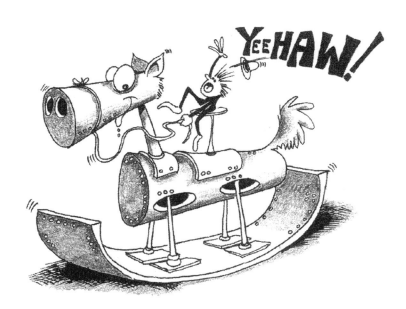

Warm up your pencils! Start your imagination engines!

Before you begin the amazingly fun drawing lessons in this book, let's warm up our drawing arms.

We are going to use curving lines to create the very cool **illusion** of **depth**. These curving lines are called **contour** lines. Contour lines help push some parts of your drawing into the background and pull other parts forward.

Look at the series of curved tubes or cylinders I have drawn below. Notice how the contour lines make the tube look 3-D.

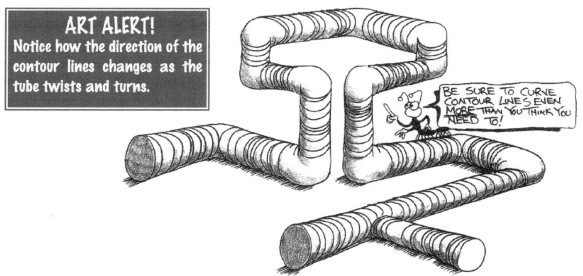

ART ALERT!
Notice how the direction of the contour lines changes as the tube twists and turns.

BE SURE TO CURVE CONTOUR LINES EVEN MORE THAN YOU THINK YOU NEED TO!

Now, practice drawing the curved contour lines on the tube below.

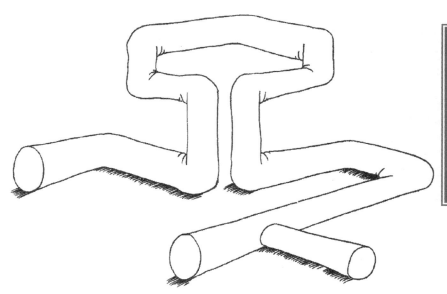

ART ALERT!
Whenever a word appears in bold, it is a very important cartooning vocabulary word. You can read a more detailed definition of these words in the back of this book.

2

DRAW! DRAW! DRAW!

PENCIL POWER ROCKET

Get ready for a blast of PENCIL POWER! One of the coolest things about cartooning in 3-D is that you can travel to imaginary lands and meet the wackiest creatures. Let's hop in our Pencil Power Rockets and launch into an unknown galaxy full of gadgets and gizmos. Who knows what strange and wacky worlds we will discover along the way!

CARTOONING LESSON #1

1

Two simple vertical lines are all you need to start this super 3-D space-traveling pencil rocket!

2

Connect the sides of the rocket with two curved lines.

ART ALERT!
Remember, words in bold are explained at the back of the book.

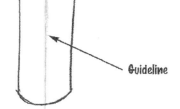

3

Draw a light **guideline** straight up the middle of the rocket. Using the guideline, draw a dark dot where the tip of the rocket will be.

Guideline

4

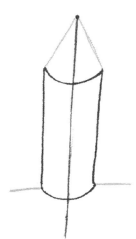

Slant the nose of the rocket. Begin the stabilizing wings at the bottom of the rocket with two horizontal lines.

5

Guide dots

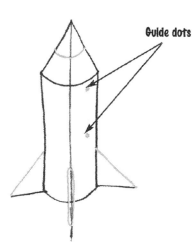

Complete the stabilizing wings. The middle wing is popping directly out of the paper toward you, so you will only see a thin edge. What a cool **optical illusion**! Then draw a **contour** line on the rocket nose and two **guide dots** on the right side of the fuselage.

Light Source

6

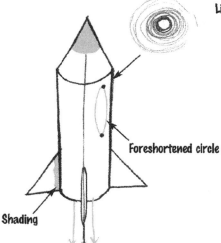

Foreshortened circle

Shading

Our imaginary **light source** will be this scribbly sun in the top right corner of our picture. Begin **shading** the side of the ship that faces away from the light. Connect the two dots on the fuselage with a **foreshortened** circle to create your command chamber, and darken in the pencil tip of the rocket. Following the vertical guideline you drew in step 3, begin **sketching** the connecting tube at the bottom of the rocket.

ART ALERT!
Flip to page 4 for step-by-step instruction on drawing foreshortened circles.

7

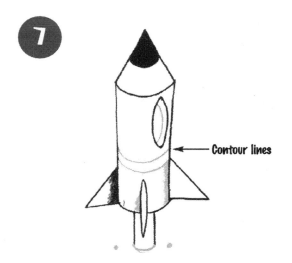

Contour lines

Curve the bottom of the connecting tube and draw two guide dots to mark where the top of the next tube will be. Define the shape of the rocket wings with more shading and add two curving lines to create a steel band around the rocket.

8

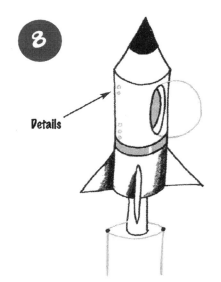

Details

Darken in the curving steel band. Leave a white space to show the light reflecting off the steel—cool illusion, huh? Then darken in the command chamber and draw a clear dome over it. **Blend** some more shading and add metal rivets to the rocket.

9

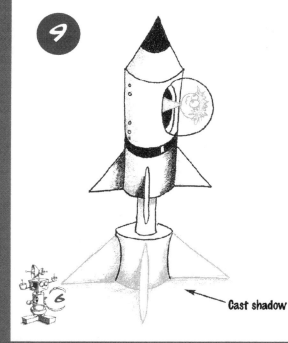

Cast shadow

Final step! Add more blended shading to the rocket body. Draw all the fun **details**, like the pilot (you), the winged fuel storage booster at the bottom of the rocket, and the **cast shadow** on the ground.

DRAW! DRAW! DRAW!

7

PIPE PET

Our Pencil Power Rocket's first stop is the cartoonist colony in Gamma Sector 4. Shortly before arriving the crew encounters a bizarre alien vessel. The alien jumps right out, smiling and waving. Everyone seems to laugh, hug, and dance at once... until the strangest creature flops out of the docking door! It's a long, twisting, tubular thing... some kind of alien Pipe Pet!

CARTOONING LESSON #2

1

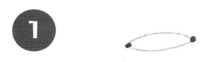

Let's start drawing this playfully perky Pipe Pet with two dots. Then draw a **foreshortened** circle by connecting the dots.

2

Draw the sides of the tube straight down.

ART ALERT!

Your foreshortened circle should look like you grabbed both sides of a circle and pulled to stretch it like a rubber band. It will help your cartoon POP off the paper in 3-D. Practice drawing 30 of these foreshortened circles in your sketchbook before you draw Pipe Pet.

3

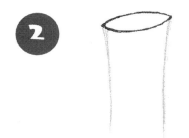

Thickness line

Contour lines

Angled line

Add a **thickness** line to the top of the foreshortened circle. Begin the first of many **contour** lines by curving a single line across the front of the tube. **Sketch** in angled lines to create the **illusion** that the Pipe Pet's body is resting on the floor.

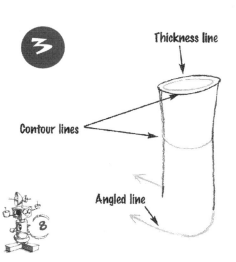

4

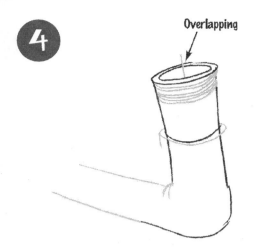
Overlapping

Draw a single line **overlapping** the top of the foreshortened circle. Add more curving contour lines to the tube. Follow the lines of the foreshortened circle to make all of the curves the same. Let's add a belt around the middle of our pet.

ART ALERT!
Thickness lines help show how wide or thick different parts of your gadgets and gizmos can be. Here we used a curving line at the opening of the pipe to show how thick Pipe Pet's metal walls are.

5

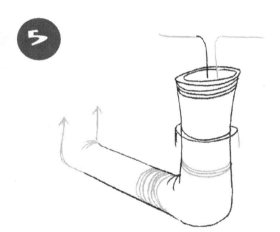

Draw more curving contour lines to add roundness to your Pipe Pet's body. Remember, the direction of the curves changes dramatically with each twist and turn.

ART ALERT!
Flip back to the warm-up to learn more about contour lines.

6

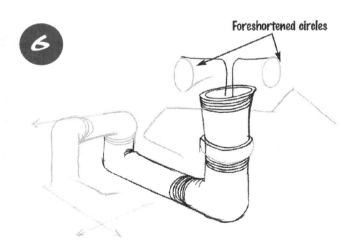
Foreshortened circles

Twist and turn the Pipe Pet's body up, across, down, and over. Add dozens more curving contour lines. **Block** in the segmented arms reaching out from the body. Then draw the foreshortened circles of the eyes.

7

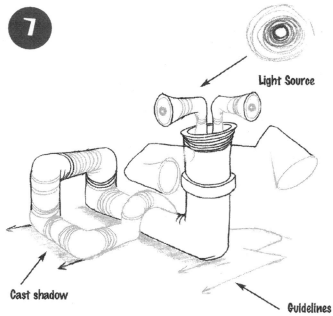

Light Source

Cast shadow

Guidelines

Curve! Curve! Curve! Curve those contour lines! Add pupils to the eyes. I like to leave a little white spot in the eye to show the light reflecting off the surface. Determine where you want to place your imaginary **light source** and begin darkening the **shadows** on the ground opposite that light source. Use **guidelines** to line the shadows up with your Pipe Pet's body.

8

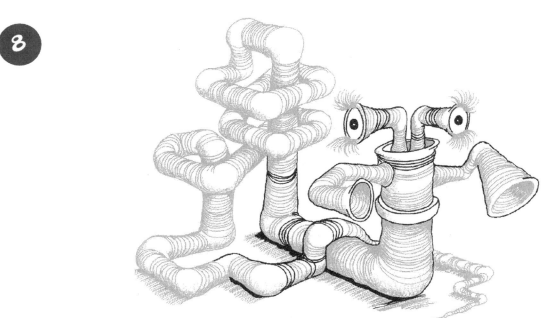

Final step! To make the tube arms look hollow, curve the contour lines in the reverse direction inside the tube. Then try **blended** shading inside the arms. Finish your Pipe Pet by cleaning up any extra lines and darkening all the outside lines and adding **details** like eyelashes. Congratulations! You have just completed a college-level lesson! You are the Cartooning Genius of Planet Earth!

DIGITAL DUDE

After 17 days on the Pencil Power Rocket, the crew is getting restless. Digital Dude started a huge food fight in the galley this afternoon. What a mess! Bits of food are lodged in all the vents and stuck in all the compartment doorways, not to mention splattered all over the pilot's uniform! Let's draw this mischievous robot dude!

1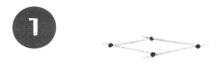

Let's begin this mischievous Digital Dude by drawing a 3-D box for the head. To draw a 3-D box, we will start with a **foreshortened** square.

2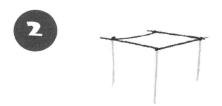

Draw the sides of the box coming down from the corners, making sure to draw the middle line longer than the two side lines.

3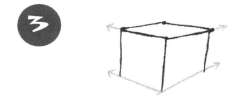

Draw the bottom of the 3-D box by following the angles and lines of the foreshortened square. This is called **alignment**.

4

Draw a long sweeping **guideline**. You will build Digital Dude's body around this line.

Guideline →

ART ALERT!

Practice drawing 30 3-D boxes before finishing this lesson. Compare the two boxes below. I used alignment to draw the box on the left, but not the box on the right. Do you see a difference?

5

Begin drawing the tube neck and two **guide** dots to place the shoulder section. Follow the curve of your guideline.

Art Alert!

Remember, words in bold are explained at the back of the book.

6

Foreshortened circles

Draw foreshortened circles for the shoulders and the popping lid on top of his head. Be sure to draw his right eye LARGER to make it appear closer, and his left eye smaller to make it appear farther away.

13

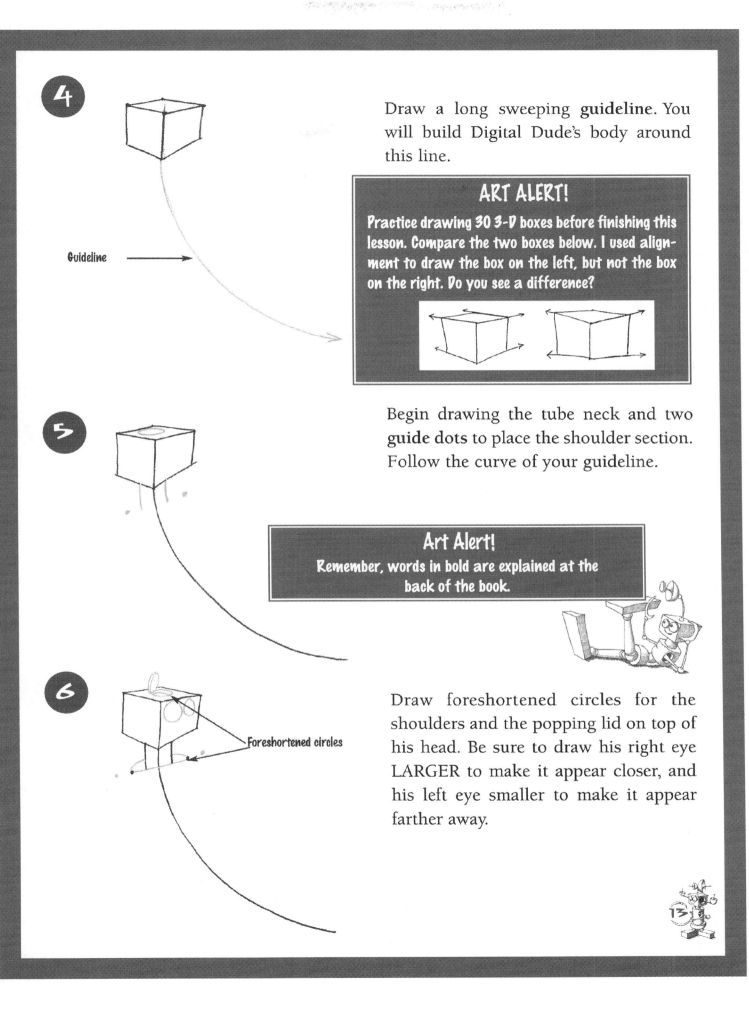

7

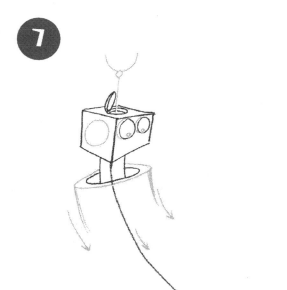

Add **thickness** lines and **details** to the bulging eyeballs. Draw the curve of the first radar antenna dish on top of the head. Then curve the body to match the long guideline.

8

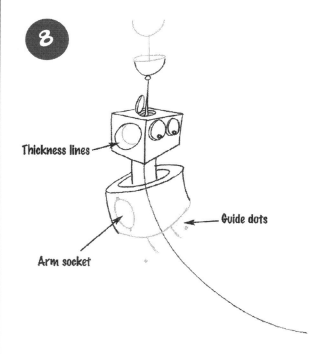

Thickness lines

Arm socket

Guide dots

Start layering the antenna dishes on top of his head, and add a thickness line to the inside of his ear. A foreshortened circle will create the arm socket. Begin drawing the torso segment with two guide dots.

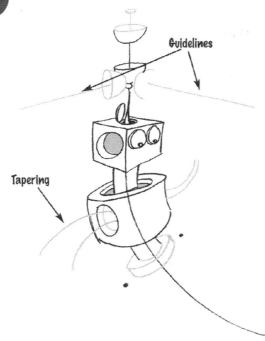

Guidelines

Tapering

Draw more antennae on top of Digital Dude's radar pole. Then draw two long guidelines out of the side antenna dishes. Darken in all the inside nooks and crannies. **Sketch** the closer arm **tapering** out of the socket from small to HUGE as it pops off the paper toward you. Draw the other arm getting teeny tiny as it moves deeper into the picture.

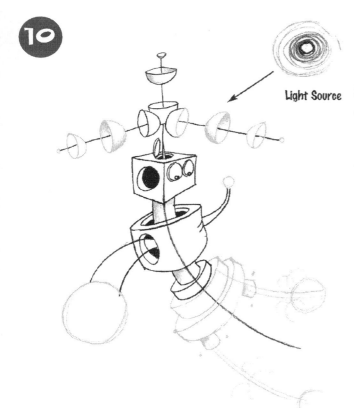

Light Source

Start **shading** in the areas opposite your imaginary **light source**. **Block** in the dude's gigantic right hand with a big sketchy circle. Add foreshortened sections to the torso. Use more guidelines to **position** the jet-propulsion steam and the billowing puff clouds. Line up these guidelines with the first long, sweeping guideline you drew.

15

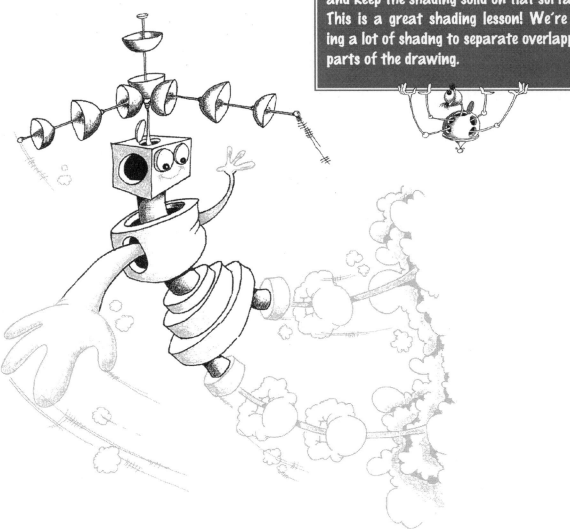

Final step! Go through the drawing and darken in all the outside edges, the shading, and the **shadows** of the nooks and crannies. Then **clean up** any extra lines. Now stand your sketchbook up on the table, step away from your drawing, and take a good look at Digital Dude. This one is ready for framing!

RIVET THE ROCKING HORSE

Let's use our cool cartooning skills to draw Rivet the Rocking Horse so we can send him out on an initial probe of Planet Z14's surface. His solid titanium super-metal casing is sure to withstand the planet's extremely hot atmosphere.

Begin this fun 3-D mechanical marvel with two **guide dots** to create a vertical **foreshortened** circle.

Tapering

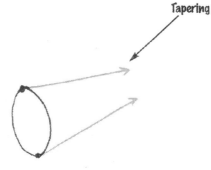

Draw two lines **tapering** back from the circle to create Rivet's face.

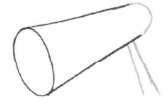

Curve the back of Rivet's head and sketch two tapering lines for the neck.

18

4

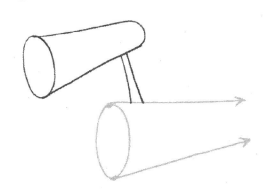

Draw another vertical foreshortened circle with lines tapering back for the rocking horse's body.

5

Overlapping

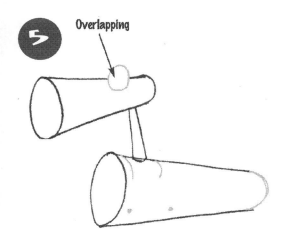

Add an eye **overlapping** the top edge of the head. Curve the back end of the horse's body, then draw two more curved lines to **position** the neck attachment plate. Draw two guide dots to **block in** the front leg socket.

6

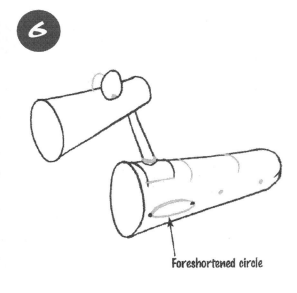

Foreshortened circle

Now the fun really begins! We're going to add more bonus **details** to Rivet's body. Draw the second eye, smaller and tucked behind the first eye. Then add the dark pupil and begin the saddle. Draw some curving **contour** lines to the base of the neck to make it look much rounder and more 3-D. Finish the foreshortened circle on the front leg socket and block in more guide dots for the back leg socket.

7

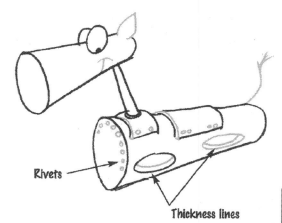

Rivets

Thickness lines

Add more detail to Rivet's face, ear, and twitching tail. Notice how quickly the rocking horse takes on a metallic look when you add the round rivets. Small details make a big difference in the overall look of your picture!

ART ALERT!
Remember to use thickness lines to show how thick or wide part of your gadget or gizmo is.

8

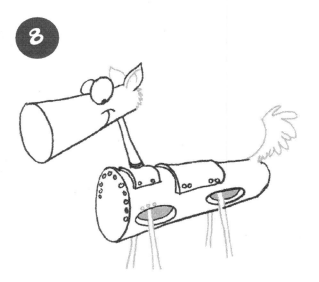

Draw two overlapping lines in the ear and . . . voilà! You have a cool, complete, 3-D ear. Draw some fur on the back of the head and the tail. Now draw the stick legs — the back legs are shorter and smaller because they are farther away in your picture. You're using the cartooning vocabulary word **size**!

9

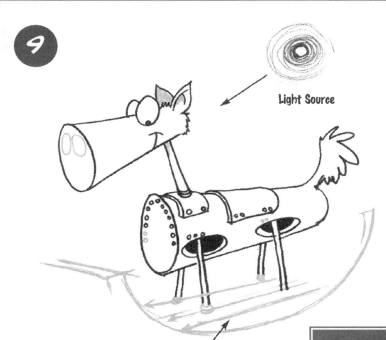

Light Source

Guidelines

Let's place our **light source** and begin **shading** the ears and under the chin. **Sketch** in several guidelines to help you place the feet. Curve the rocking skid with a long line beneath the feet.

ART ALERT!
Remember, words in bold are explained at the back of the book.

10

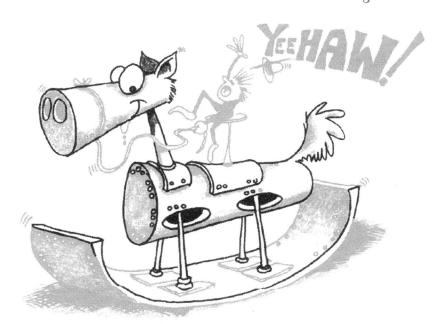

YeeHAW!

Final step! Ride 'em, cowboy! Yeehaw! Add more details and erase any extra lines. Congratulations! This was a difficult drawing, and you did a wonderful job — way to go!

21

TOTAL TECH TRANSPORT

CARTOONING LESSON #5

Our voyage to planet Z14 in Gamma Sector 4 had been a routine expedition up until about 20 minutes ago. Our sensors have alerted us to a large vessel approaching at sub-light speed. I just looked out my viewing bubble shield and saw the strangest-looking alien ship...

1

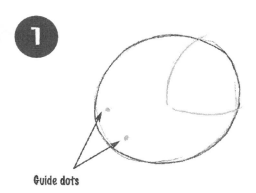

Guide dots

Start this peculiar alien vessel with a large circle. Relax your pencil line — it is okay to be messy. **Sketch** in the frame of the window shield and draw two **guide dots** on the opposite side of the circle. They will become the porthole for an extender arm.

ART ALERT!
Flip to page 8 for instructions on drawing fore-shortened circles.

2

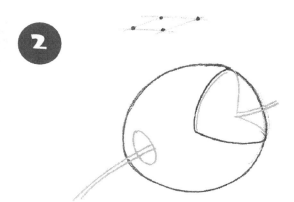

Draw a **foreshortened** circle on the side and extend an arm out of it. Then draw four guide dots above the circle. Connect them to create a foreshortened square above the ship. Add more **detail** to the window shield, and extend another arm out the other side of the ship.

ART ALERT!
Forget how to draw a foreshortened square? No worries! Just turn back to page 12.

23

3

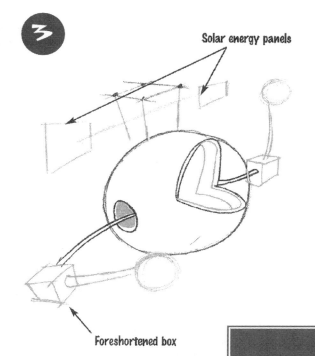

Solar energy panels

Foreshortened box

Draw solar energy collection panels at the top of the ship. Then add a foreshortened box to the elbow joint of both arms. Block in the ship's robot hands with scribbled circles.

ART ALERT!
Notice how the distant solar panel is much smaller than the close one? We're using the cartooning concept of size again. In a 3-D drawing, larger parts of an object appear to be closer than smaller parts.

4

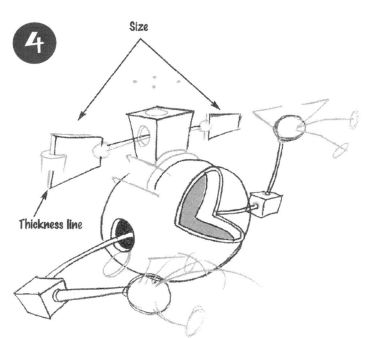

Size

Thickness line

Add **thickness** lines to the solar panels. Then add as much extra detail as you want to the box unit above the ship. Draw a curving saddle to harness the box to the ship's body. Then darken in the control area and add light sketchy lines to **block** in more of the robotic hands.

5

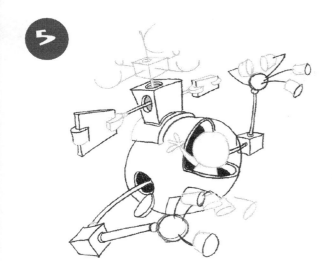

Block in the multiple radar dishes spinning at the top of the ship. Begin sketching the waving alien pilot. Then draw the ends of the robotic fingers — they look like giant foreshortened marshmallows! Complete the details and begin cleaning up the extra lines. Then draw the interplanetary language translator headset on the alien's head.

6

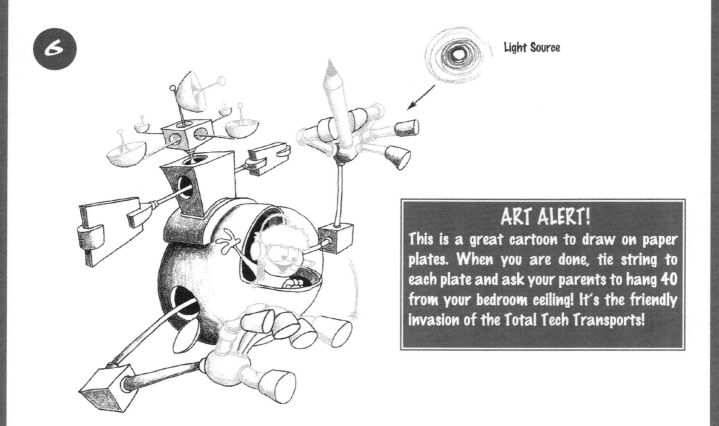

Light Source

ART ALERT!
This is a great cartoon to draw on paper plates. When you are done, tie string to each plate and ask your parents to hang 40 from your bedroom ceiling! It's the friendly invasion of the Total Tech Transports!

Final step! Add the imaginary **light source**—let's pretend it is the seventh sun of the galaxy of Sigma Sector 5. Now darken in all the areas opposite that light source. Also, notice how I made the nooks and crannies under the fingers and inside the radar dishes super-dark.

SUPER SUBMARINE

It appears that Rivet has discovered an enormous subterranean ocean on planet Z14. I have dispatched my two best science officers to assist Rivet in the exploration of this vast underground body of water. These brave explorers will need the aid of a special gizmo, the Super Submarine, to navigate the dangerous waters. Let's draw the very slick 3-D cartoon illustration of this Super Submarine!

1

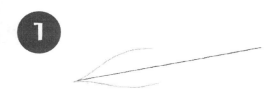

Start by **sketching** a quick **guideline** slanting off to the right at a slight angle. Begin molding the nose of the submarine with two curved lines.

ART ALERT!
This first guideline will be used throughout this entire lesson. Guidelines are very helpful in keeping your drawing organized and 3-D.

2

Thickness line

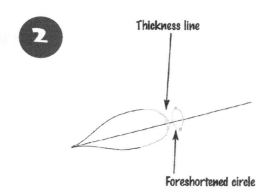

Foreshortened circle

Following your main structural guideline, curve the back of the nose. Begin the connecting tube with a curved **thickness** line. Start sketching the rear module with a vertical **foreshortened** circle.

3

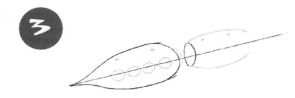

Keeping a sharp eye on your main guideline, sketch in the row of porthole windows along the side of the front module. Draw two **guide dots** at the top of each module.

27

4

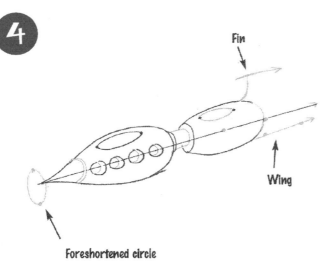

Fin

Wing

Foreshortened circle

Connect the guide dots with foreshortened circles. Then draw another foreshortened circle for the front propeller and add thickness to the side porthole windows. Follow the main guideline to **block** in the **position** of the top and bottom stabilizing fin and wing.

ART ALERT!
The side wing is a foreshortened square just like the one we drew back in cartooning lesson #3.

5

Thickness lines

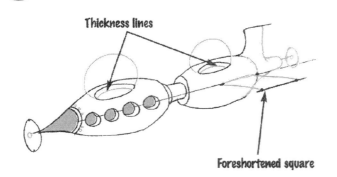

Foreshortened square

Darken in the nose cone and add some metal rivets. Darken inside each window, add thickness lines to the top edges of the control viewing pods, and draw in the covering bubbles. Complete the side wing and tall back fin. The back propeller is another foreshortened circle.

6

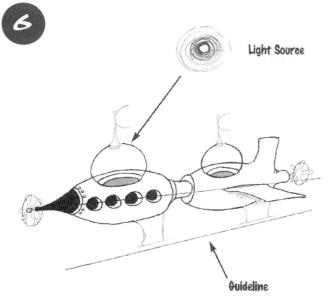

Light Source

Guideline

Draw another guideline below the ship and use it to position the two bottom keels. Let's place the imaginary **light source** directly above the submarine and begin adding **shading**.

7

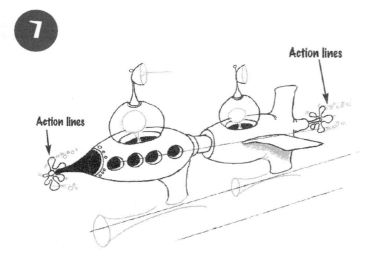

Action lines

Action lines

Trail a bunch of bubbles behind each of the propellers to enhance the illusion of instant animation! Keep working on more cool **details**, like the two scientists and the bottom propulsion tubes.

8

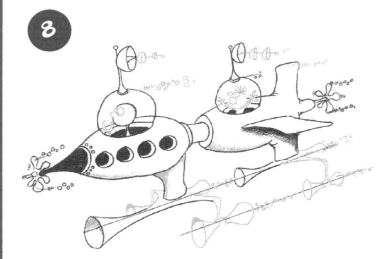

One of the most visually pleasing steps in any drawing is the shading process. Each layer of shading you add to your drawing will make the edge POP right off the paper in 3-D! POP!

9

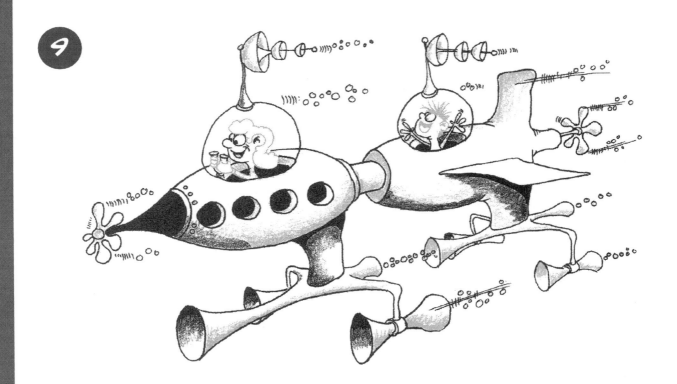

Final **cleanup** and detail step! Whew! This was a *very* detailed drawing that relied heavily on **alignment** and guidelines. You have mastered this lesson well, my faithful cartooning student. Now may the tides be with you as you voyage into the underground ocean in your spiffy new Super Submarine!

HOVERING HIPPO

Several hours from the shore of the underground ocean the scientists in our Super Submarine spot an island overflowing with a peculiar species of flying hippos. In this lesson, you will learn to draw in PERSPECTIVE. The Hovering Hippo is above eye level–you are looking up at it. From this point of view you will be drawing the bottoms of objects.

1

Begin with a large, relaxed, sketchy circle. Draw another relaxed circle **overlapping** the first one to **block** in the **position** of the Hovering Hippo's drooping head.

2

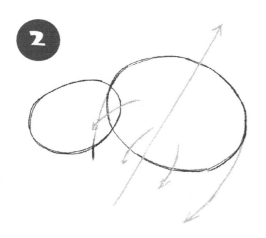

Slant a tilted **guideline** through the bigger circle to block in where the helicopter power pack will be attached. Curve guidelines down from the body to place the front and back legs. The back leg is larger than the rest and curves directly off the back of the body.

3

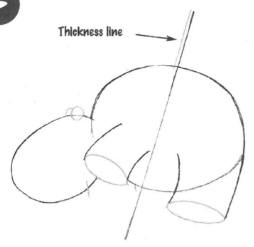

Thickness line

Draw the **thickness** of the top propeller shaft and place two **guide dots** to position the helicopter blades. Connect the lines of the legs with **foreshortened** circles. Then overlap the small hippo eyes and begin the other front leg tucked under the hippo's chin.

ART ALERT!

Try drawing the "looking-up" views of the objects to the right. Foreshortening and size are the most important concepts to keep in mind when you draw from this perspective. The word perspective comes from the ancient Latin root word *spec*, meaning to see. Other modern words that are related to this Latin root word *spec* — spectator, spectacle, spectacular — all have something to do with seeing.

4

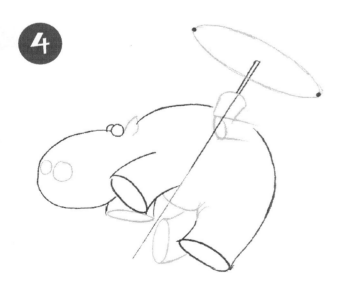

Connect the guide dots you drew in step 3 to place the propeller. Then add a few **wrinkles** overlapping the top of the back leg. Adjust the tummy line and draw in the smaller "peekaboo" legs tucked behind the hippo's body. Slant the foreshortened circles on the bottoms of the feet to create the **illusion** that the feet are dangling below the hippo's body. Begin adding details.

5

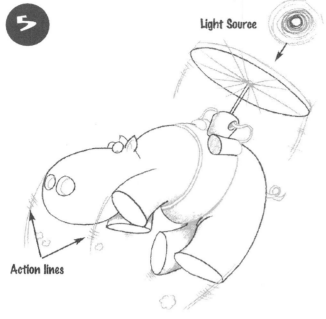

Light Source

Action lines

Draw the guidelines for the helicopter rotor blades radiating out from the center of your propeller shaft. This is called one-point **perspective**. Curve the long lines of the harness around the hippo's belly. These curved lines will help give your hippo 3-D shape and volume. Begin the **shading** on the power pack, legs, and tummy. Draw the thickness on the nostrils. Add **action lines** to animate your Hovering Hippo, along with a few puffy, tufty cloudbursts to create more motion.

6

Final step! Whoop! Whup! Whoop! The helicopter blades are spinning really fast. Here comes the Hovering Hippo for another pass. Be careful! Duck! Keep your head low as you add the final details to this fun drawing lesson. Add more shading and erase any extra lines. Nice job! Keep up the hard work.

Now that you know how to draw the helicopter blades and power pack gizmo, use your brilliant brain to think up dozens of ideas for your own gadgets and gizmos.

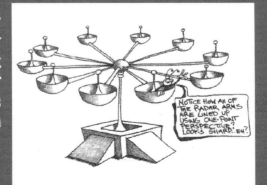

NOTICE HOW ALL OF THE RADAR ARMS ARE LINED UP USING ONE-POINT PERSPECTIVE? LOOKS SHARP, EH?

TELESCOPING TARANTULA

Our scientists have discovered the reason it is bright as day in the deep-underground ocean world. It is crawling with glowing spider-like creatures with telescope laser-light eyes! It's like a brilliant multicolored laser-light show!

Let's begin this really bizarre, glowing, binocular-eyed, roof-clinging critter with a simple swooshing dome-shaped line.

Curve the bottom of the dome to **block** in the basic shape of the brainy body. Begin the telescope pole on top.

Draw a quick **guideline** above your **sketch** to block in the direction of the binocular eyes. Place two **guide dots** to create a **foreshortened** circle for the eyepiece.

Complete the eyepiece. Then draw spirals around the neck. Block in the shape and direction of the front legs. Match the angle of your top main guideline.

Guide dots

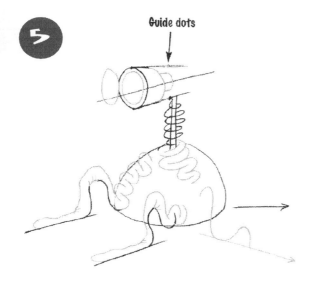

Draw the other eyepiece smaller and more foreshortened than the front eyepiece. Place more guide dots behind the eyepiece to block in where the back section will be attached. Add **thickness** to the tarantula legs and use **overlapping** wrinkles to give them the lumpy texture of brains — ick! Now continue the lumpy, folding **texture** by curving the brain coils up along the side of the dome and down the middle.

6

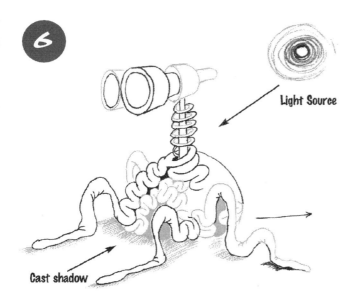

Light Source

Cast shadow

Complete the curving back section of the binocular gizmo and add thickness to the neck coil. Darken in the spaces between the brain coils to create a deep, recessed look. Let's place our imaginary **light source** and begin drawing **cast shadows** on the ground off to the left of the legs.

7

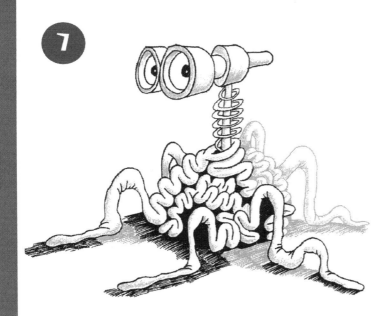

Final step! Add more brainy, squishy, oozing, overlapping **details**! Draw miles and miles of twisting, lumpy brain coils! Icky-cool! Then darken in all the outside edges and add dark, **blended shading** to all the surfaces opposite the imaginary light source.

ART ALERT!
Now it's time for you to write a super-fantastic adventure story about this Telescoping Tarantula.

TOTAL TAIL TWISTERS

A peaceful tribe of insectoids has colonized the steep bluffs of an island off the coast of the underground ocean. These creatures have figured out how to harness the tremendous energy of their long-tailed pet dinosaurs, and have constructed an ingenious power-generating rolling-spool gadget.

CARTOONING LESSON #9

1

Begin this fantastic cliff scene with a **single, simple** line. Then curve the edge to the right to form the base of the cliff.

2

Place a **guide dot** to the left of the cliff base to **block** in where the ledge will go.

3

Using a curved line, draw the ledge at the base of the cliff. Did you notice that the ledge is really one half of a **foreshortened** circle?

4

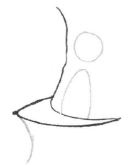

Add some of the insectoid colony **details**, like a door and a window. Continue the edge of the cliff down with a slightly curving line.

5

Thickness Line

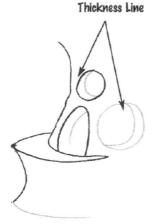

Complete the door and window with **thickness** lines. Add another window, and curve in the base of the second cliff shelf. Place another guide dot to **position** the next ledge.

6

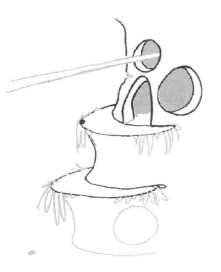

Draw the lower shelf and darken the inside of the door and windows. Add another window below — the more details, the cooler your drawing will look! Droop grass over the edge of the shelves and **sketch** in the large pole. Add another dot to position another shelf. You can draw 50 shelves if you want — the more, the better!!!

41

7

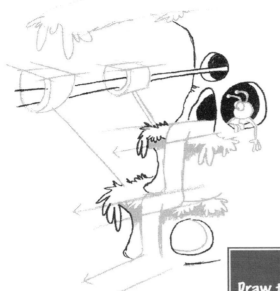

Add lots of 3-D details! Then comes the really fun part of this lesson — the super-long, totally twisted tail. Begin the long tail with sketchy **guidelines**. It is VERY important to drop the tail straight down so that it does not slant. Quickly bend the tail along the top of the second shelf, and suddenly drop it straight down. Keep these lines vertical. You can continue this tumbling action for 1,000 steps if you want. It looks so very cool and 3-D.

ART ALERT!

Draw tufts of drooping grass hanging over the edge of cliffs and canyons to create the 3-D illusion that the edges fall away into the depths of your picture. To enhance this illusion, darken the shadow directly under the drooping grass tufts. Drooping gras give a very old, ancient, mossy texture to your pictures.

8

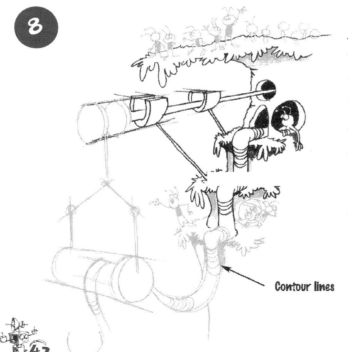

Contour lines

Add a large crowd of insectoids gathered to watch the action! Work on the spools, the hanging support contraptions, and the thickness lines. Add several curving **contour** lines to the tail to give it shape and direction. Change the direction of these curved contour lines as the tail hits each lower shelf. Use **more** guidelines to block in the lower power spool.

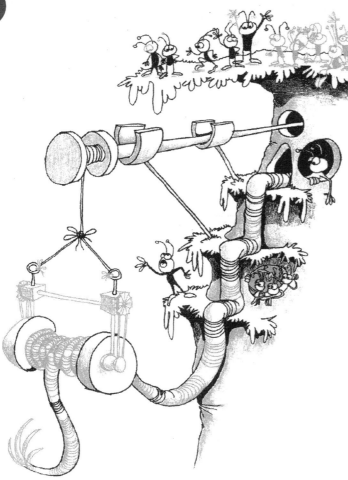

Awesome job! Look at how intricate and fun you have made this Total Tail Twister! Excellent work! Use lots of curving contour lines to wrap the tail around the lower spool. Darken in all the edges, add as many bonus details as your genius brain desires, and clean up all the extra lines. This is definitely a great completed drawing to show your parents. Go show them right now — they are going to be so impressed with your cartooning skill!

Then open up your sketchbook and invent a gizmo to help these intrepid insectoids build their ingenious power-generating gadgets. Here's mine:

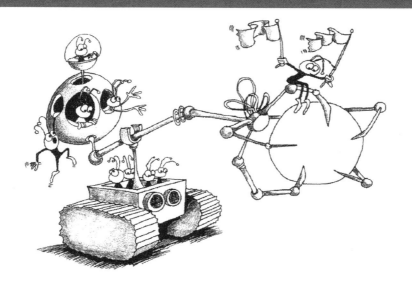

44

ROBOT REX

Our scientists decide to stay on the island and help the tribe of insectoids with their Total Tail Twister, when they hear something crashing toward them. It's giant. It's monstrous. It's Robot Rex! In this lesson you are going to draw Robot Rex's head above eye level, just like you did with the feet in the Hovering Hippo lesson. But Rex's body will be below eye level. It sounds hard, but it's quite easy.

CARTOONING LESSON #10

1

Begin the shape of the head with a **foreshortened** circle.

2

Draw the sides of the head going up from each end of the foreshortened circle. Then curve the top of the head.

ART ALERT!
Remember, words in bold are explained at the back of the book.

3

Block in where the eye bulbs will stick up out of the top of the head. Then **sketch** in the neck.

45

Place **guide dots** on either side of the eye posts, then draw a foreshortened circle around the top of each eye post. Draw another foreshortened circle to connect the neck to the head.

Draw the sides of the eye bulbs going up, to continue the looking-up **perspective**. Then move back down to the neck. Draw thick fore-shortened circles for shoulders below eye level. Isn't this multiple perspective view fun?

Begin the sharp, snaggly, gaping Robot Rex mouth. Add a few more foreshortened shoulder layers. Remember to curve each foreshortened circle below, around, then behind the layer above it.

7

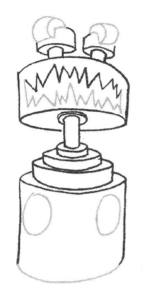

Draw the bulging eyes saddled atop the eye bulbs and add the bottom of the toothy gaping mouth. Block in the torso and draw foreshortened circles for the arm sockets. Place guide dots on each side of the torso to **position** the waist band.

8

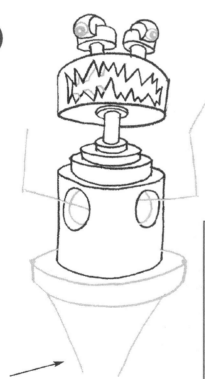

Tapering

Draw the foreshortened waistband and add **thickness** lines. Then draw two **tapering** lines down from the waistband. Draw thickness lines in the arm sockets and block in the arms reaching out of the sockets. Add more **details** to the eyes. Begin drawing the thickness of Robot Rex's sharp teeth.

9

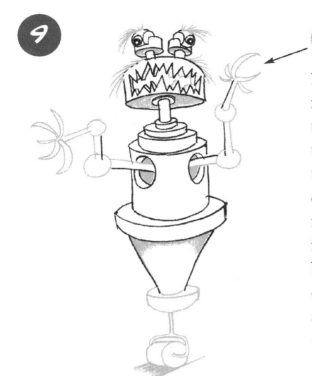

Light Source

Following the thickness rule, complete drawing the thickness lines all across Robot Rex's terrifying, gaping, snaggly, foul-smelling teeth! Add details to the arms and darken in the inside of the arm sockets. Add a foreshortened disk to the bottom of the cone and a rolling wheel foot. Determine where your imaginary **light source** will be placed and begin **shading**. Make the **shadows** especially dark under each overhanging ledge. Start adding bonus details like the long scraggly eyebrows, hair, and pinching claws — ouch!

10

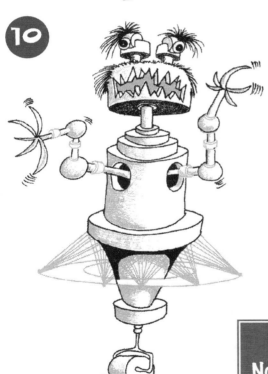

When you draw the metal wire hoopskirt around Robot Rex use guide dots to create a wonderful pattern. Radiate the lines away from each dot. Try placing the dots in different positions to experiment with **overlapping** effects! Whew! You did it! That drawing was absolutely terrifying. If you are worried about having Robot Rex nightmares tonight, don't fret! I know for a fact that Robot Rex eats only marshmallows and an occasional chunk of cotton candy! Finish Robot Rex with a dark outline, shadows, more shading, and more details.

ART ALERT!
Now that you can draw Robot Rex, try drawing his cousin, Spike.

49

PLUMBING PLANET

It's amazing what can happen in your drawing when you take one simple idea and mix in a bunch of brilliant bonus ideas from your imagination. For example, take one long foreshortened tube, turn it into a row of tubes, and add lots of bends, turns, twists, and rotating cuffs. Why stop now? How about adding faucets, levers, hinges, and handles? Suddenly you've made the leap from a simple 3-D tube to a totally hyper-complex underground plumbing planet. A very cool environment for your 3-D cartoon gizmos and gadgets to live in! Whew, YOUR imagination potential inspires me!

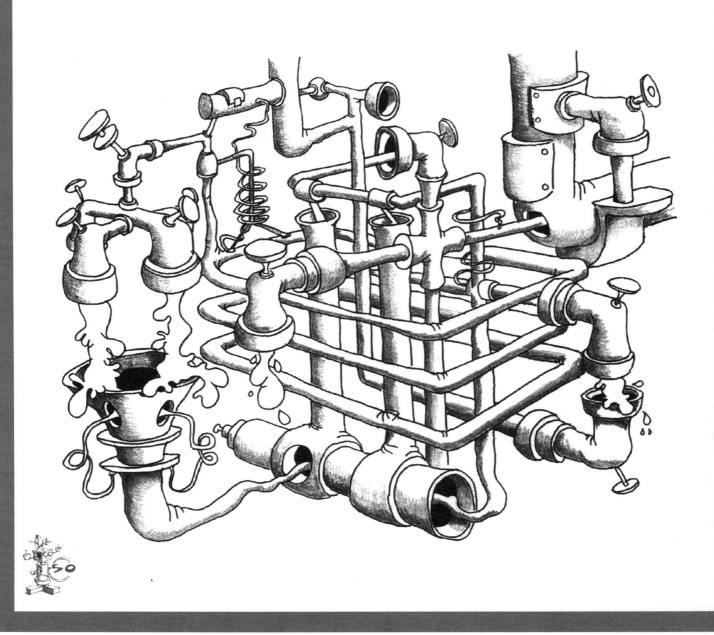

CONGRATULATIONS, YOUNG CARTOONING GENIUS!

Way to go! You have successfully completed 11 super-detailed 3-D cartooning lessons! Wow! You are now drawing at cartooning university genius-graduate level. Congratulations!

HERE ARE A FEW POINTS TO REMEMBER...

1. Practice drawing in your cartooning journal, or sketchbook, every day. The more you practice, the more 3-D your drawings will look.

2. Create a cartoon gallery of your brilliant artwork—on your refrigerator, your bedroom door, a wall, or anywhere you can. Mail copies of your 3-D cartoons to your grandparents, aunts, uncles, and friends. I want you to share your awesome talent with your family and the whole world!

3. Be sure to visit my Web site at **WWW.MARKKISTLER.COM** to draw more cartoons and tour the digital student art gallery.

DREAM iT!
DRAW iT!
DO iT!

Look for all the books in my
Draw! Draw! Draw! series:

Monsters & Creatuers
Cartoon Animals
Crazy Cartoons
Robots, Gadgets & Spaceships

62

DRAW WiTH ME!

You can learn from me personally in many different ways!

- **Other books:** Find my other drawing books, for kids and for adults, in your local bookstore, in online bookstores, or on my website: www.markkistler.com.
- **Real-time classes with me:** Learn with me at school, on line, or in a summer camp!
 - ○ **Live, weekly webcast lessons:** Interact and chat with me while you learn—I would love to see you! Sign up for my lessons at www.markkistler.com.
 - ○ **Summer art camps:** I offer summer art camps all summer long, all over the country! Learn more at www.markkistler.com.
 - ○ **School assemblies:** The best part of my cartooning career is having the opportunity to teach "Dare to Draw in 3-D" assemblies at more than 100 elementary schools each year. I offer both live and virtual assemblies! Visit www.markkistler.com for more information about my school visits and workshops.
- **Super awesome video lessons:** Learn at your own pace through my interactive, pre-recorded classes. I've created 400 super-cool lessons just for you. Find them at www.draw3d.com, or look for free samples on YouTube!

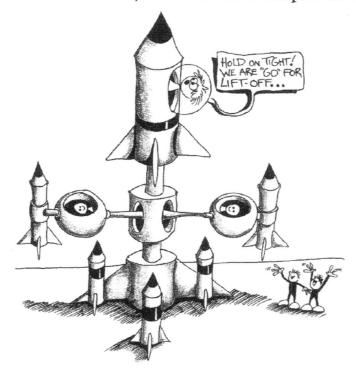

Learn these words and practice them each day in your cartooning journal. The more you practice, the more brilliantly 3-D your drawings will appear!

3-D	When you draw in "three-dimensions," you are creating a picture that has width, height, and depth. Every picture you have ever drawn has width and height. This is called a 2-D, or two-dimensional, picture. To successfully draw in 3-D you need to create the optical illusion of depth All the words below will help you create the look of depth in your picture.
Action Lines	Small curved lines drawn at the ends or tips of a cartoon to make it look like the cartoon is moving.
Alignment	Use lines you have drawn earlier in a picture as reference lines to help you know where to position new lines.
Blend	Smudge shading with your finger or a tissue to make it look like one smooth change from dark to light. Blending helps you show that an object is curved or rounded.
Blocking	Roughly draw in the basic shape of your cartoons, using light sketchy lines. This is how you begin to mold a 3-D cartoon. Then you add layers of detail, and finally clean up the extra lines.
Cartooning Journal	You really need to keep several sketchbooks or cartooning journals in different sizes on hand to draw all day long. It's easy to make a bunch of these just by gathering lots of scrap paper from your school recycling scrap paper tubs. Have your parents help you cut these stacks of papers into five different size pads of 30-50 sheets each. Make some the size of your palm, some the size of a piece of bread, some the size of a tablet, and some the size of your front door!
Cast Shadow	see Shadow.

Cleanup	This is the final stage in creating a very cool 3-D cartoon . Use an eraser to carefully clean up any extra lines and smudges.
Contour	Lines that curve around an object to give it shape and make it look like it takes up space.
Depth	If width is how wide a cartoon is, and height is how tall a cartoon is, then depth is how much space a drawing looks like it takes up from back to front.
Details	You really start to have fun when you begin adding lots of your own extra touches to your picture—like clothes, hair, a goofy smile, or even freckles. The more unique details you can think of to add to your cartoon, the more brilliant it will look!
Foreshort-ening	When you squish a shape to create the illusion that one edge is closer to you than the other.
Genius	This word describes how smart you are because you can draw 3-D cartoons so brilliantly!
Guide Dots	Always place guide dots when you are drawing foreshortened circles and fore-shortened squares. These guide dots will help you keep the shapes nice and foreshortened.
Guidelines	Always use lines to lightly block in a sketch of your cartoon. Guidelines help in drawing accurate angles on cast shadows and overlapping objects, and in pushing objects way deep into your picture.
Illusion	see Optical Illusion.
Imagina-tion	The great stuff you have bubbling around in your brain that enables you to think up all these great cartooning in 3-D ideas!
Light Source	The spot on your drawing where the light is coming from. The shadows and shading will be on the opposite side of the drawing—the side that faces away from light.
Optical Illusion	Our main goal with these cartoon drawing lessons is to trick your eye into thinking that the objects you have drawn on a flat piece of paper are popping out in 3-D!

Overlapping	To make an object in your cartoon look closer than another object, draw it in front of the other object.
Perspective	This is when you draw objects that look like they are above you—like Hovering Hippo and Robot Rex's head—or objects that appear to be below you, like Robot Rex's body. Sometimes you look up at an object. Sometimes you look down at the object. This is perspective. One-point perspective is when all the lines in a drawing meet in one spot. For example, when you drew the helicopter blades on Hovering Hippo's propeller pack, all of the blade lines met in the center at the same point.
Position	Draw objects lower in the picture to make them appear closer to your eye. Draw objects higher and smaller to make them appear farther away and deeper in your picture.
Shading	Darken the side of the object that faces away from your imaginary light source. Be sure to blend this shading on curved objects, and use a solid tone on block objects. Shading is a very important key to drawing in 3-D!
Shadow	Draw shadows on the ground next to objects in your picture. Shadows should be opposite your imaginary light source to create the illusion that the object is popping off the ground and right off your paper!
Size	Draw objects larger if you want them to look closer than objects that are drawn smaller in your picture.
Sketch	The light rough lines drawn at the beginning of a drawing to get the basic shapes down on the paper. You can darken in the lines you want to keep in the final cleanup stage.
Tapering	When part of a drawing—like Mummy Man's leg—gets smaller and smaller at one end.
Texture	The look and feel of something—like rough, smooth, or hairy.
Thickness	Lines that help show how wide part of your gadget or gizmo is. Thickness can make holes look deep, pipes look solid, and robot teeth look 3-D.

MARK KISTLER - BIOGRAPHY

Mark Kistler, with inimitable enthusiasm and style, has taught millions of children how to draw through his bestselling books, his popular PBS television series, his on and off-line classes and summer camps, and his more than seven thousand school assembly workshops around the world, including Australia, Germany, England, Scotland, Mexico, Japan, Spain and the United States.

He starred as Commander Mark and Captain Mark in the hit PBS television series The Secret City, The Draw Squad, The New Secret City Adventures, and his self-produced PBS series Mark Kistler's Imagination Station, which won an Emmy Award in 2010.

Mark's children's books include *Learn to Draw with Commander Mark, Mark Kistler's Draw Squad, The Imagination Station, Drawing in 3-D with Mark Kistler, and the four-book series Draw! Draw! Draw!* (originally titled *Dare to Draw in 3-D!*). His first book written for adults, *You Can Draw in 30 Days*, has become a category leader and perennial bestseller.

Online, Mark offers popular live and recorded classes. His YouTube videos alone have generated more than a million views. He has received more than a million letters and emails containing 3-D drawings from children around the world.

Mark deeply believes that learning how to draw builds a child's critical thinking skills while nourishing self-esteem. His positive messages on self-image, goal setting, dream questing, environmental awareness and the power of reading have inspired millions of children to discover their awesome individual potential.

Mark lives with his children in Houston, Texas, United States.

www.MarkKistler.com || www.MarkKistlerLive.com || www.draw3D.com
Facebook: https://www.facebook.com/artistMarkKistler
Twitter: @Mark_Kistler

Printed in Great Britain
by Amazon

33327146R00040